Running is no easy sport.

Trust me, I get it. Getting in the miles isn't a piece of cake. Being a good runner isn't for the feeble. It takes dedication. It takes patience. Most of all, being a great runner takes a whole lot of heart. From my heart to yours I hope this book helps you believe in the power of working hard, being kind, and achieving your goals.

From the designer, Courtney Cota

IT'S NEVER *too late* TO TRY *something new*

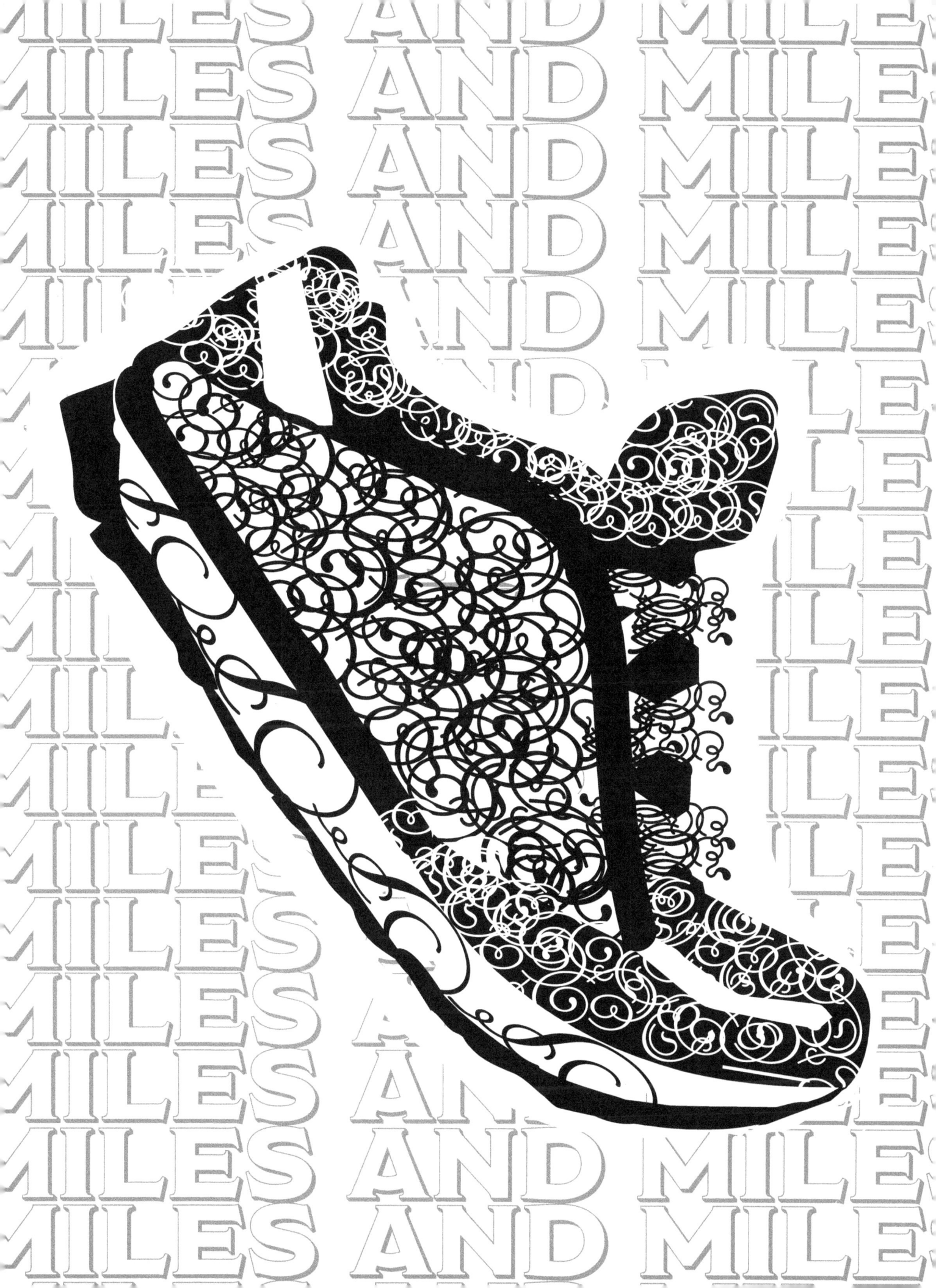

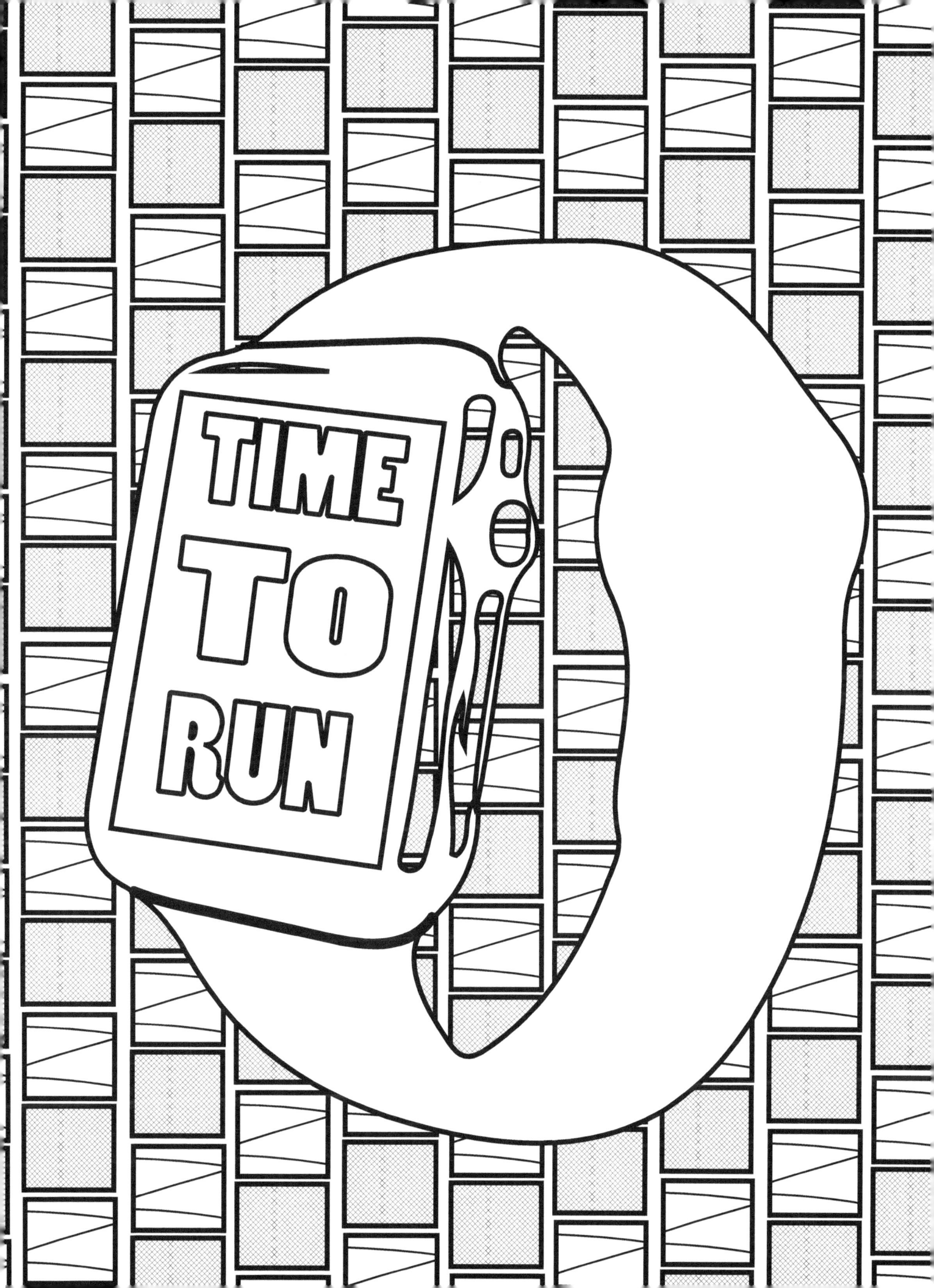

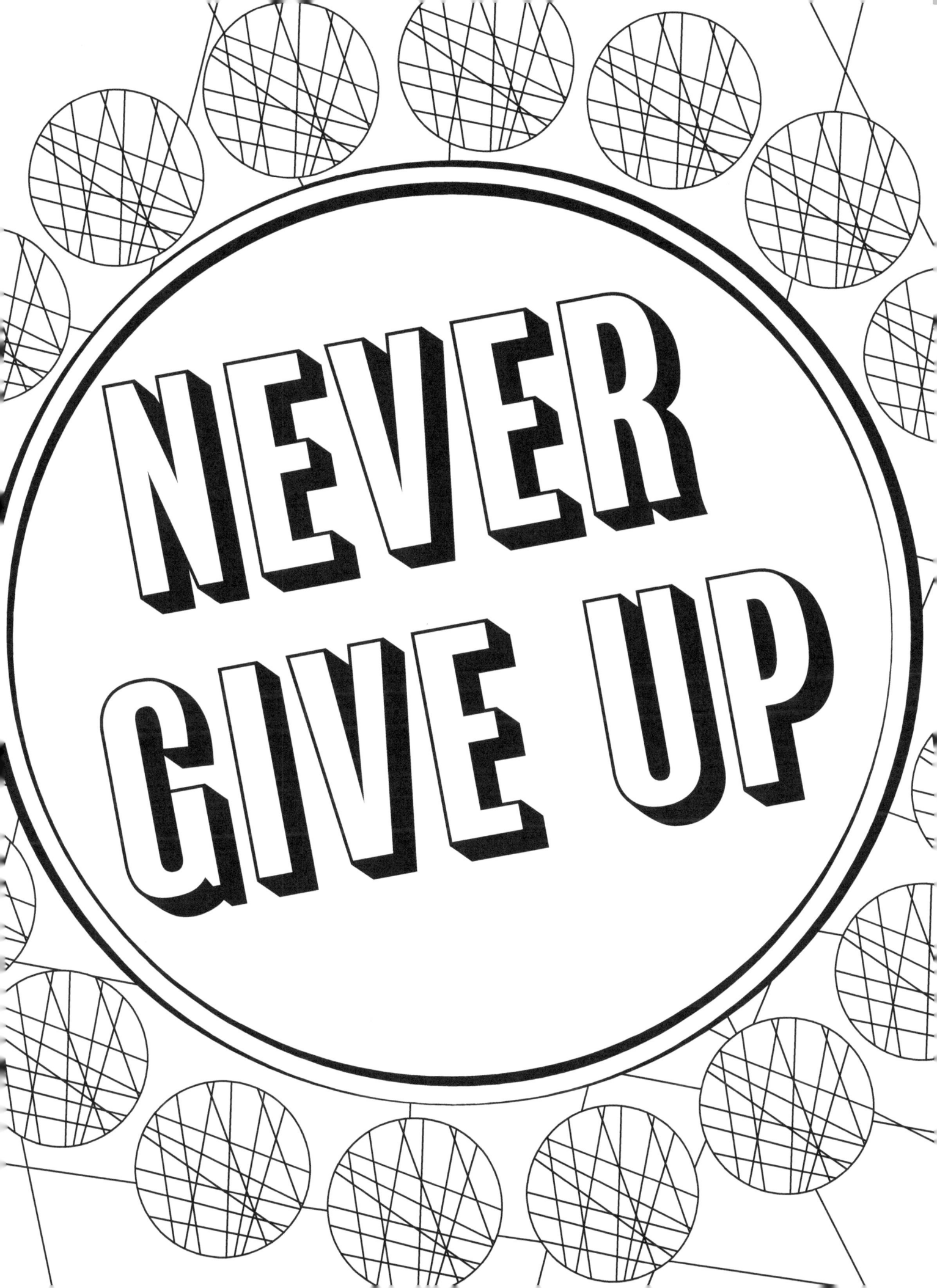

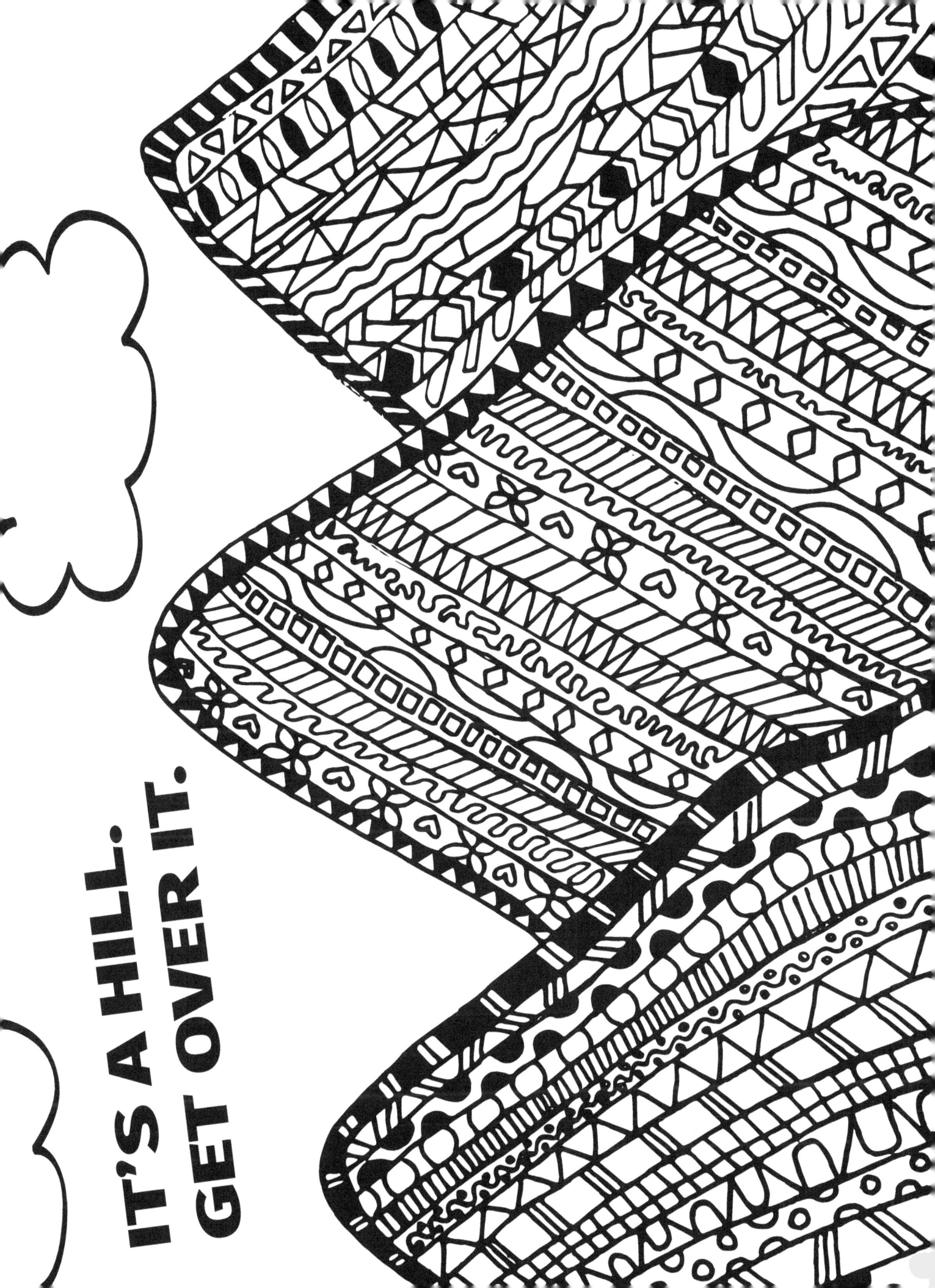

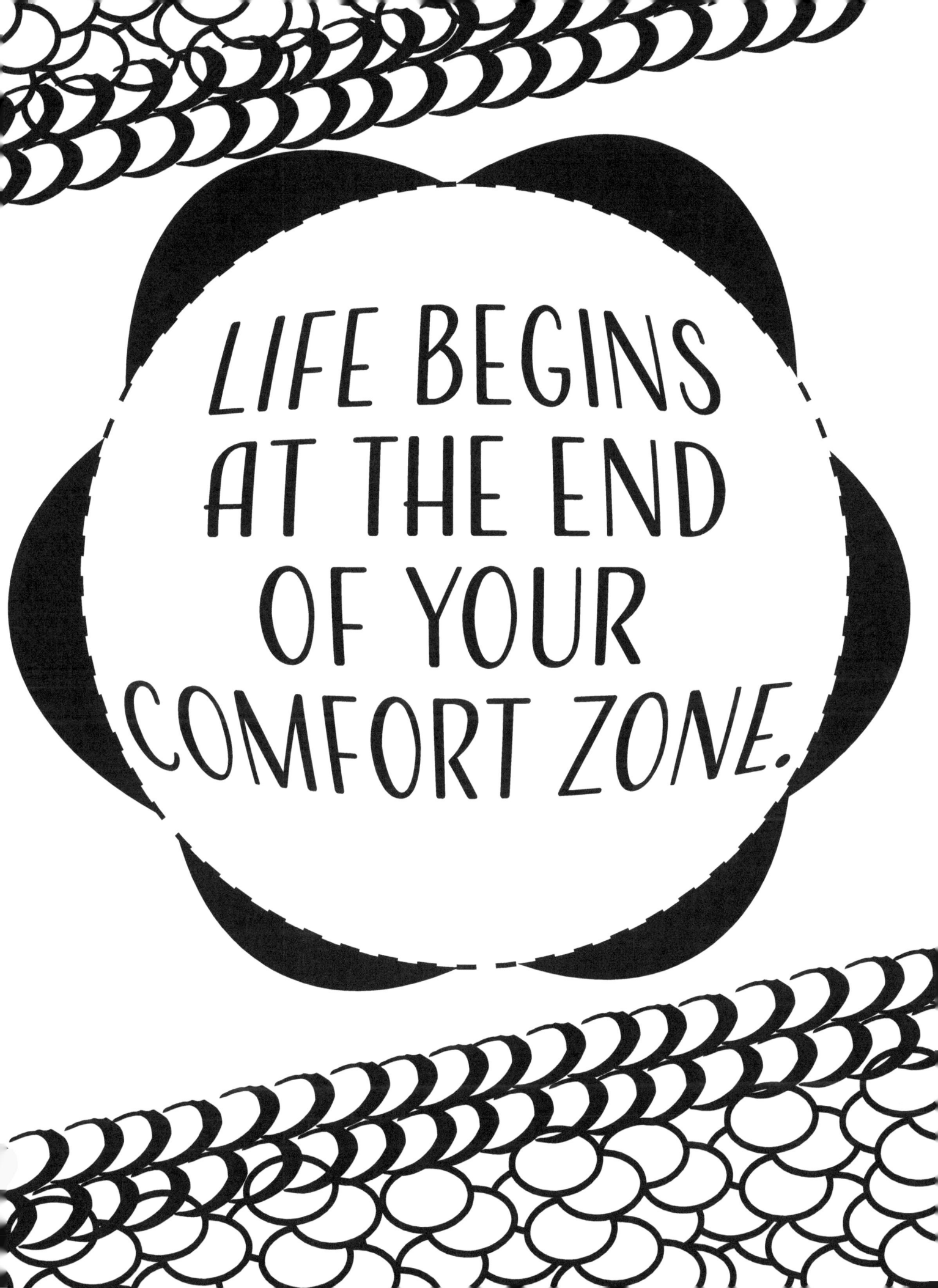

★★★★

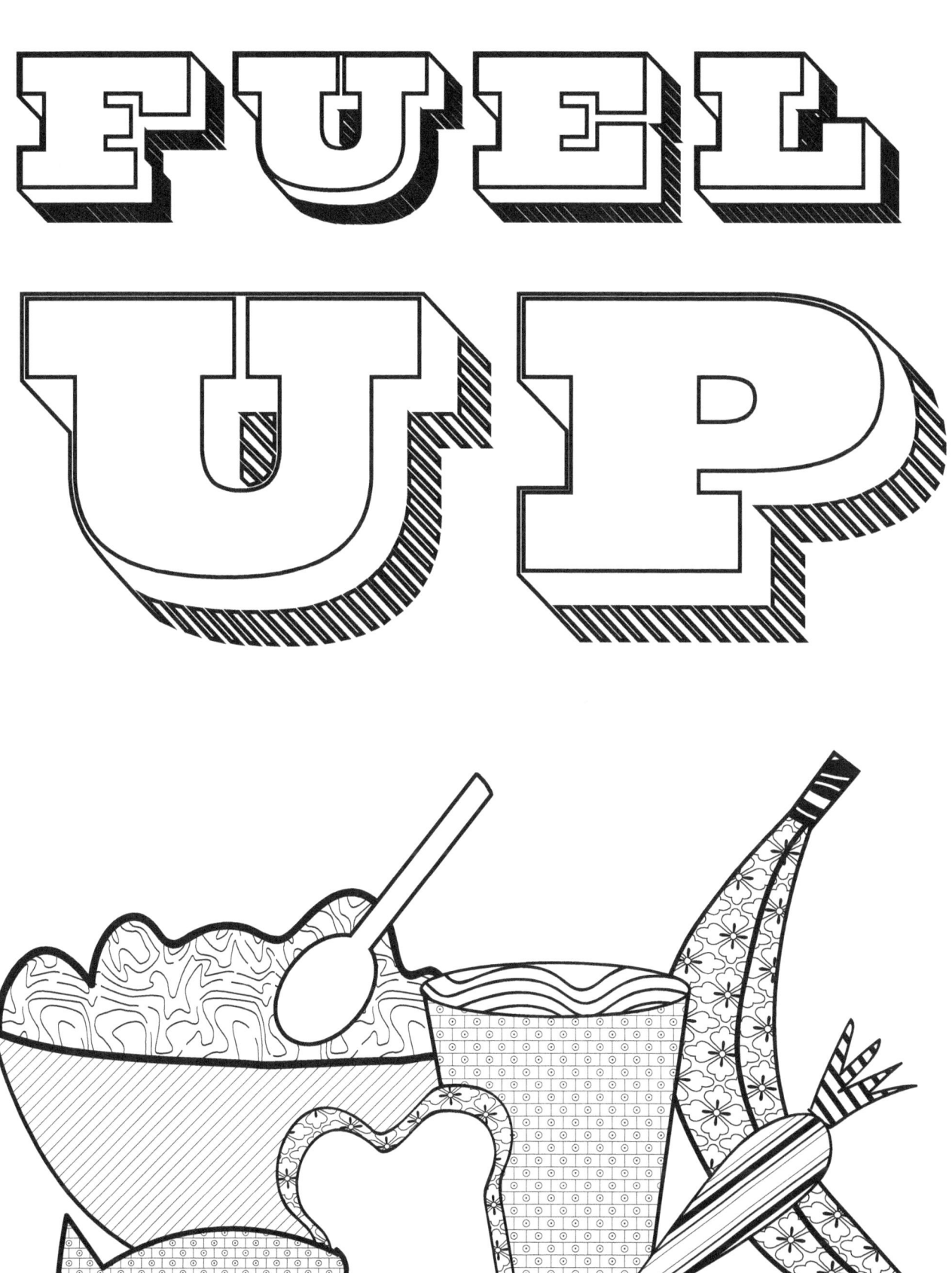

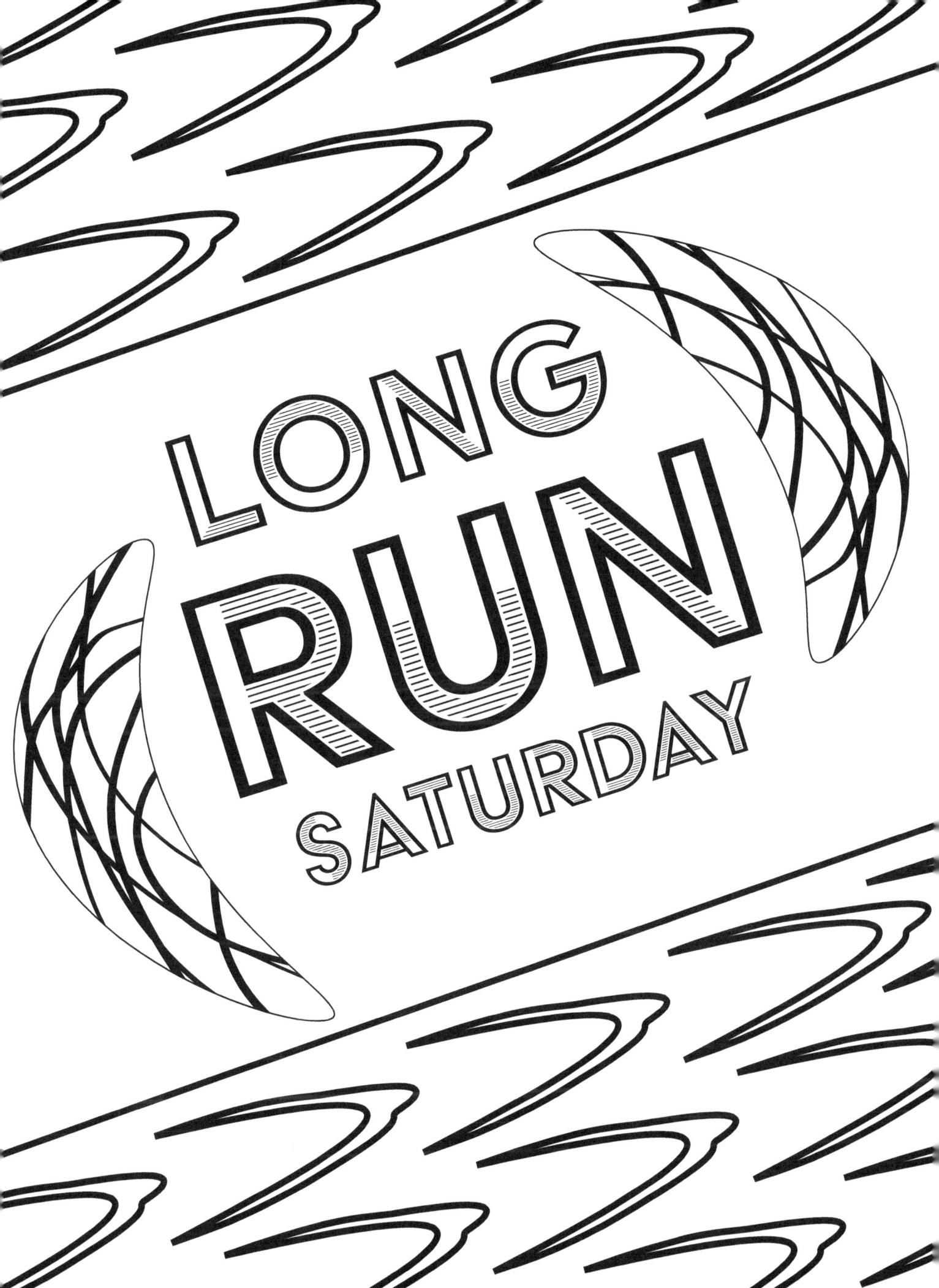

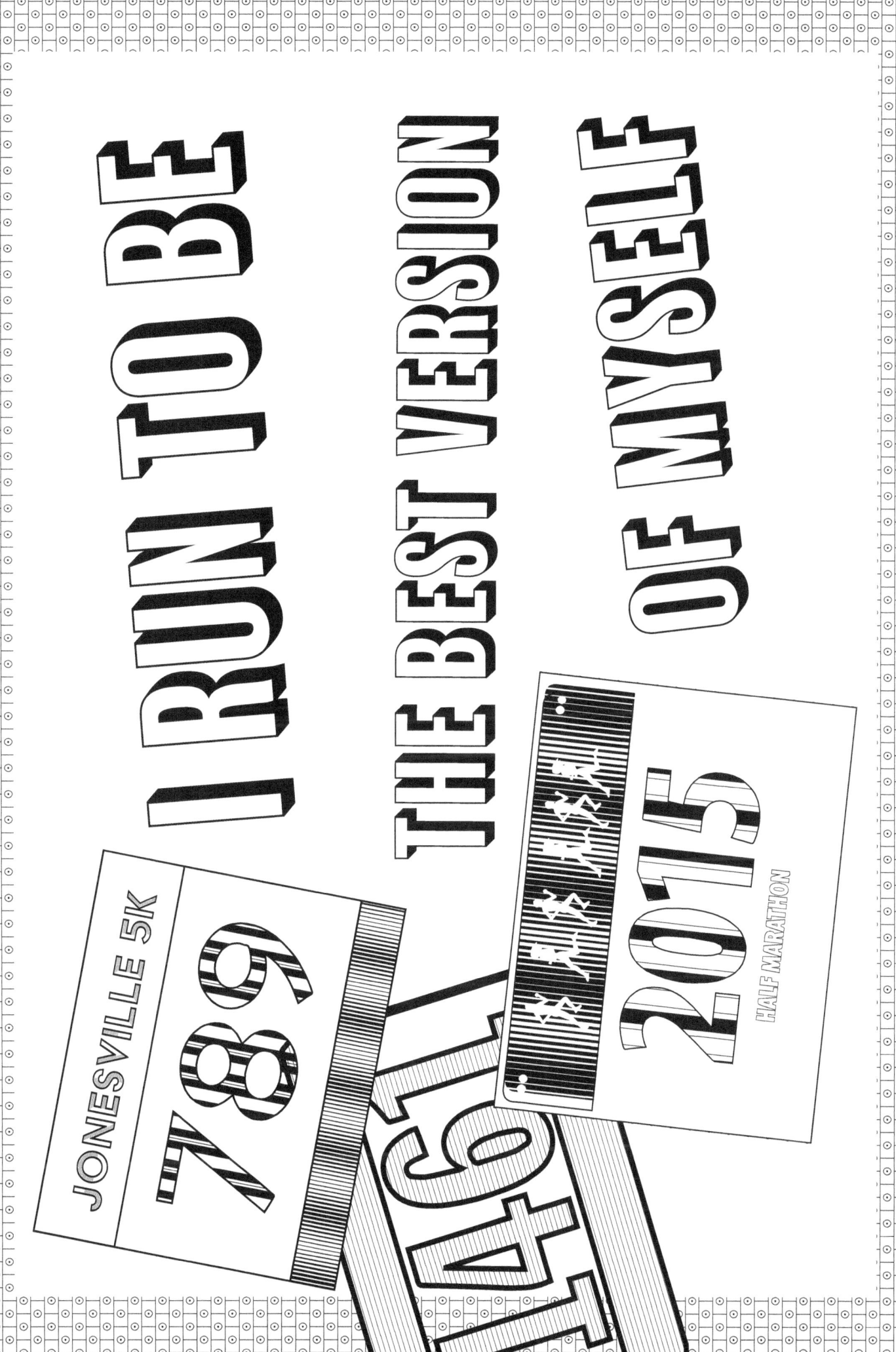

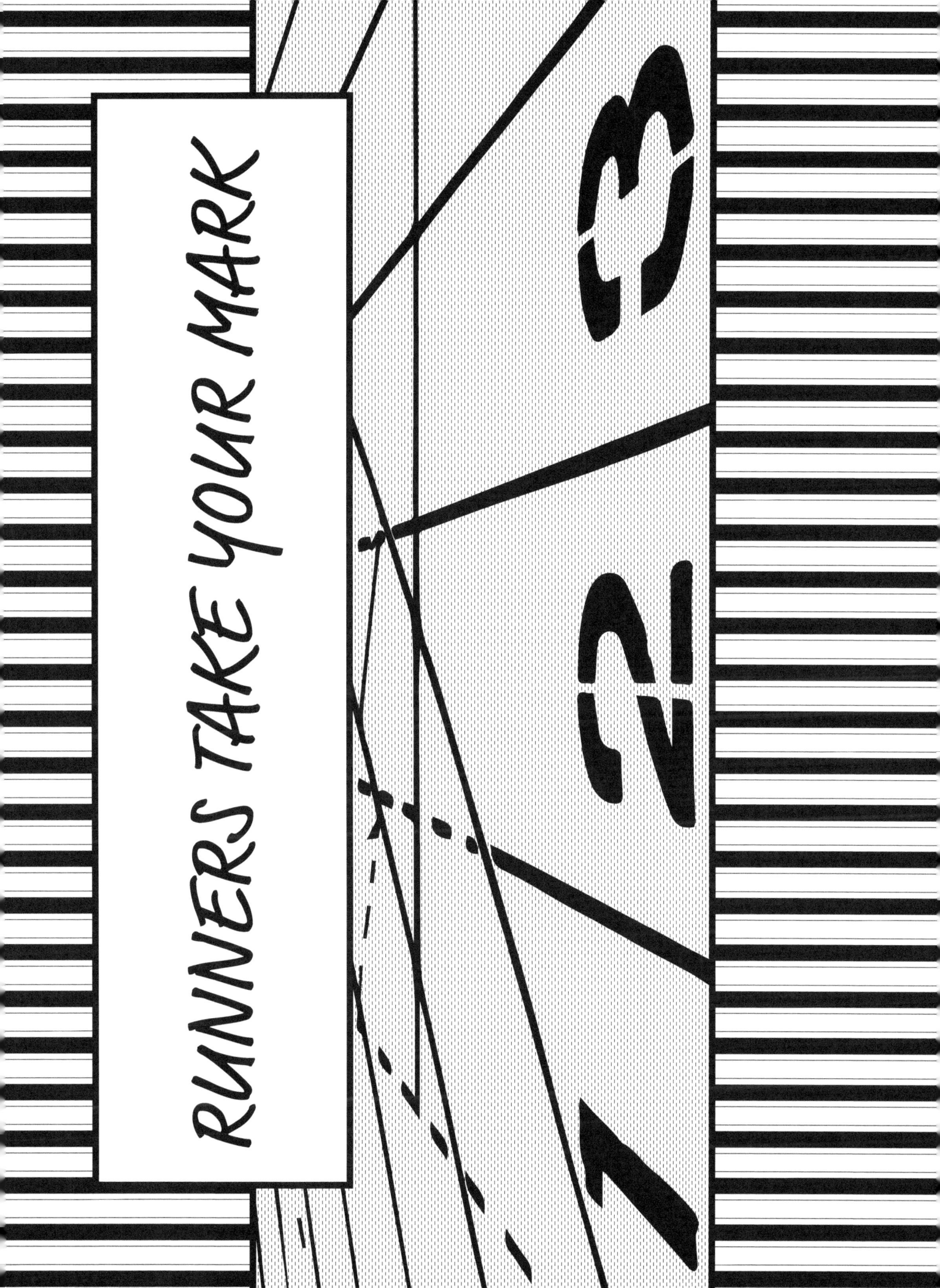

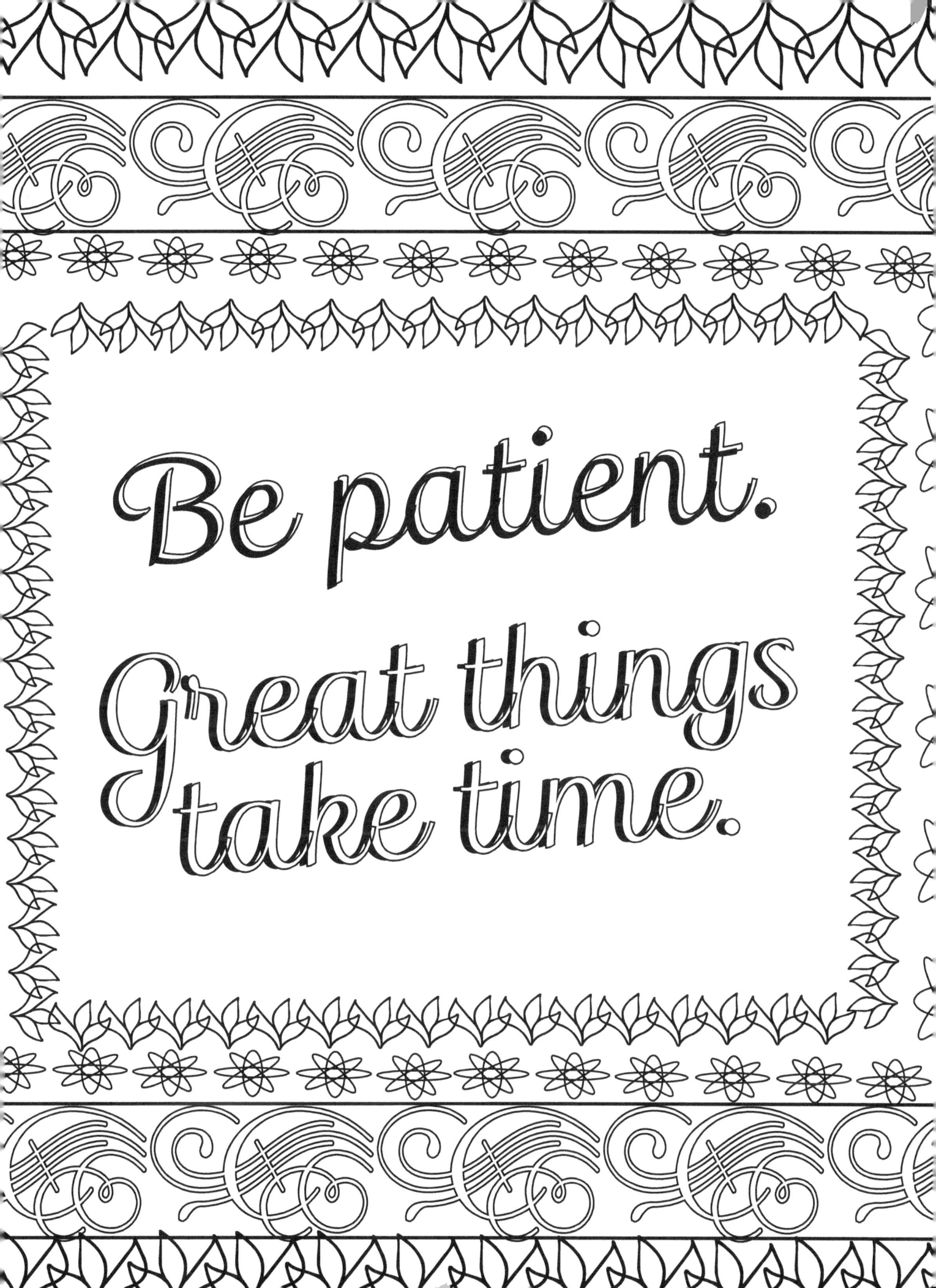

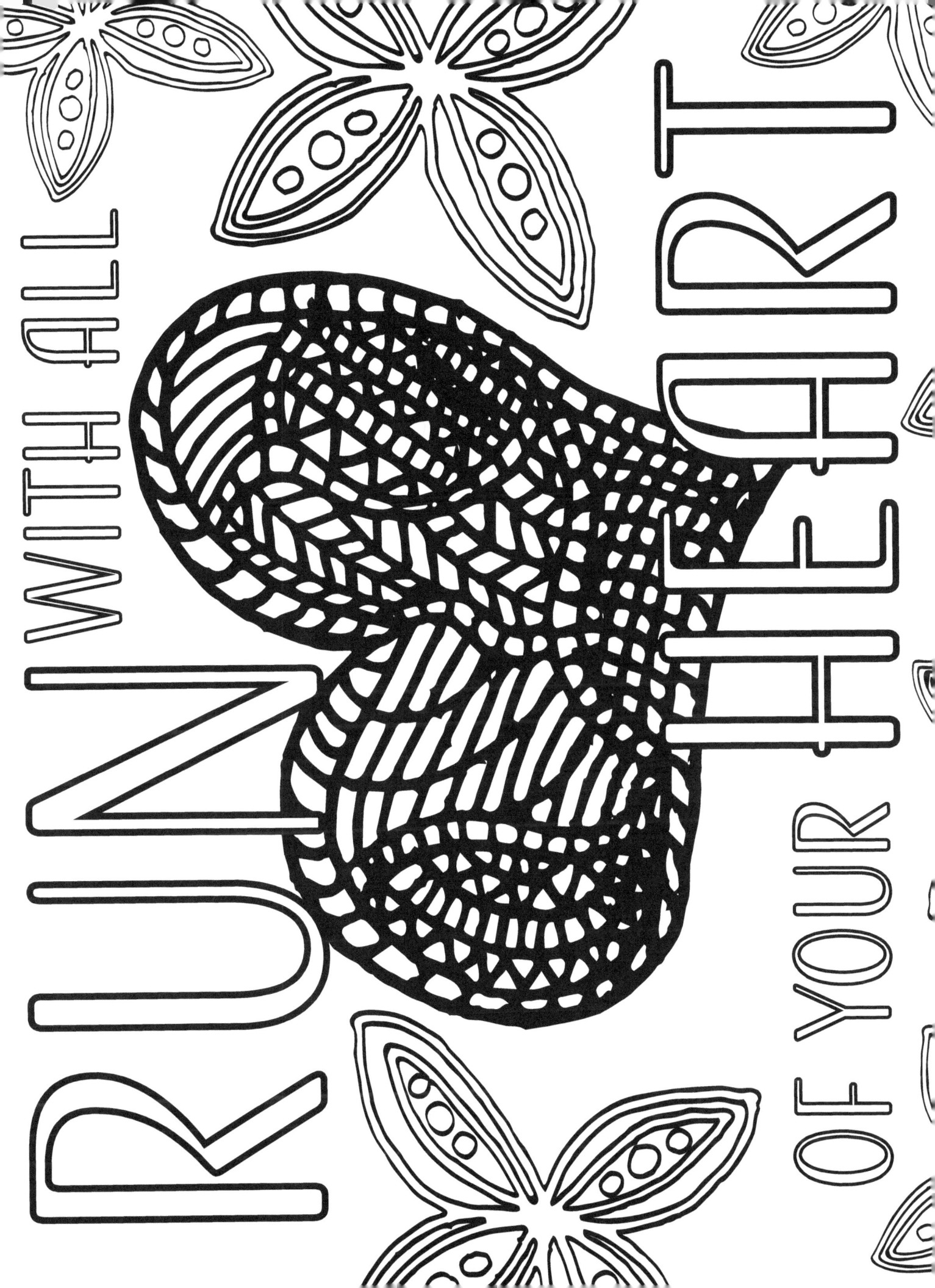

WORK HARD.

STAY HUMBLE.

★★★★

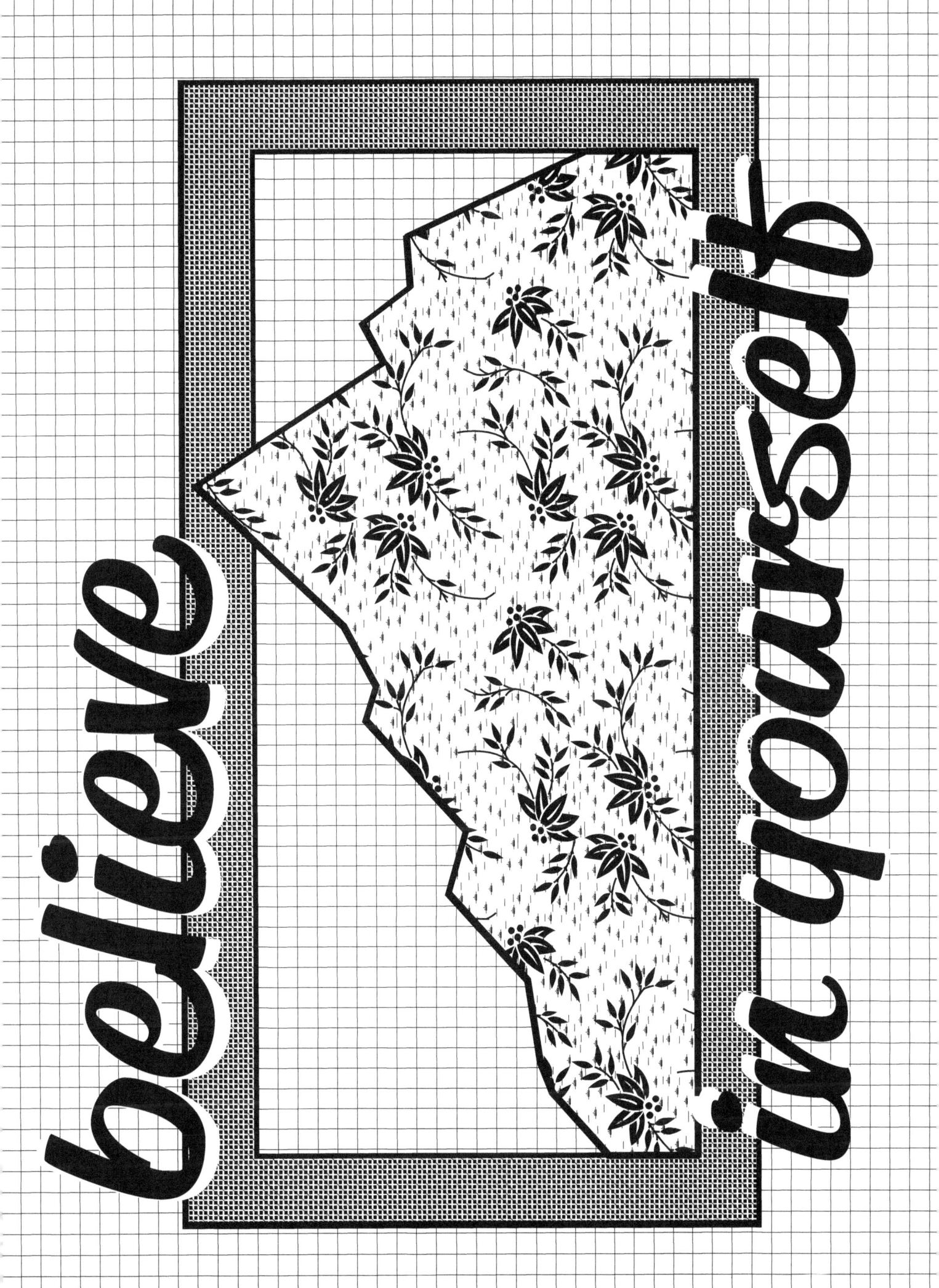

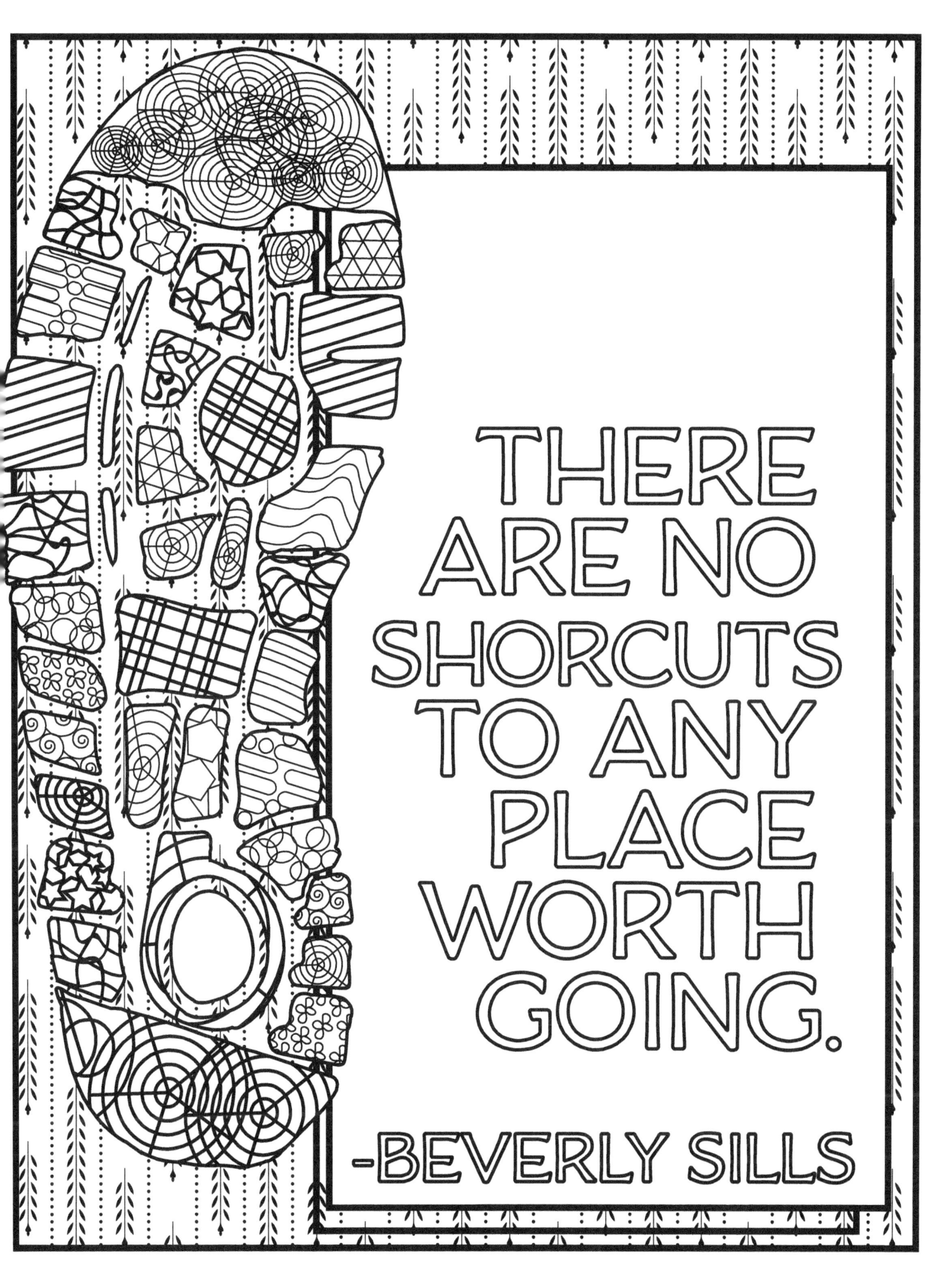

when you feel like QUITTING remember why you STARTED

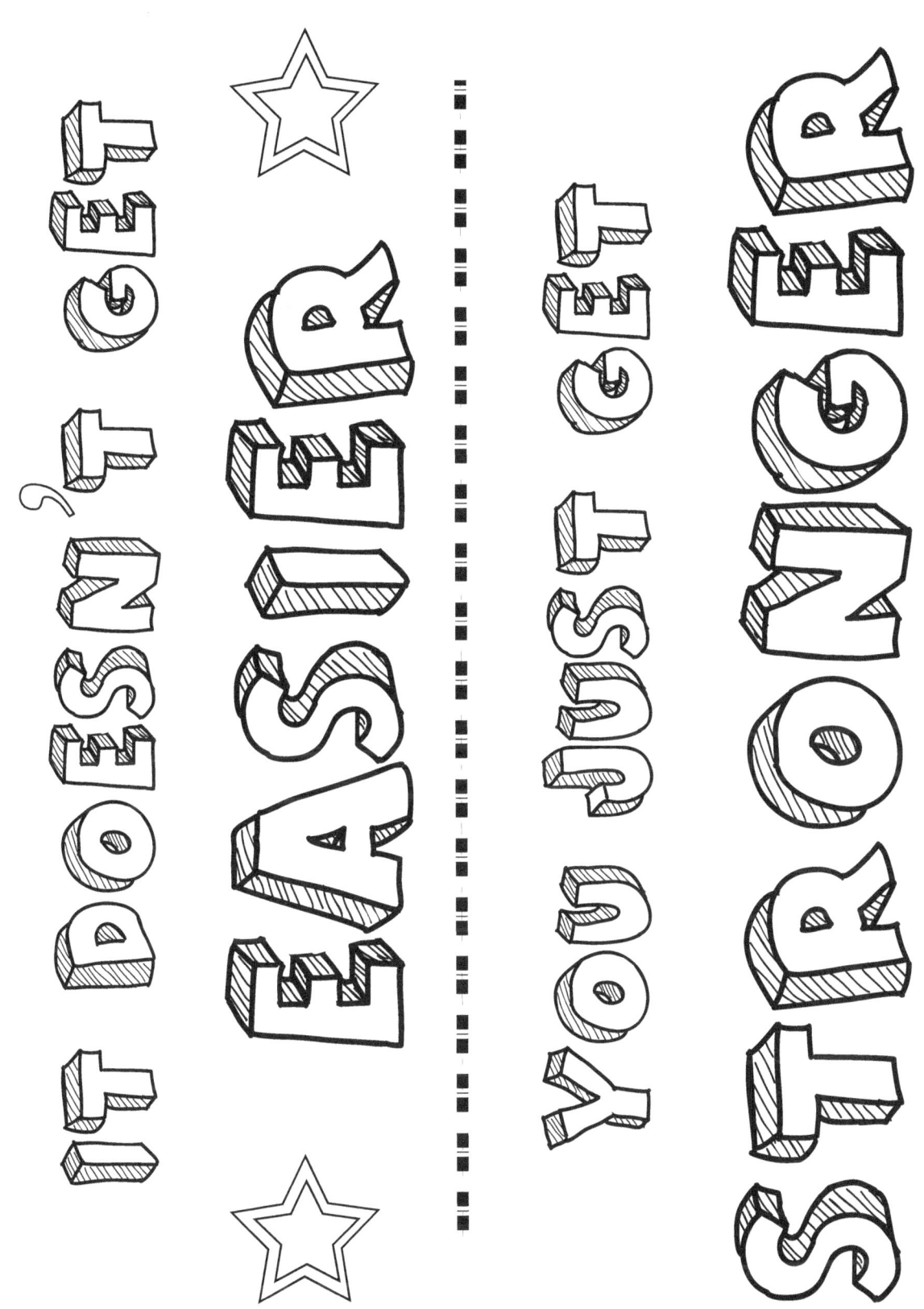

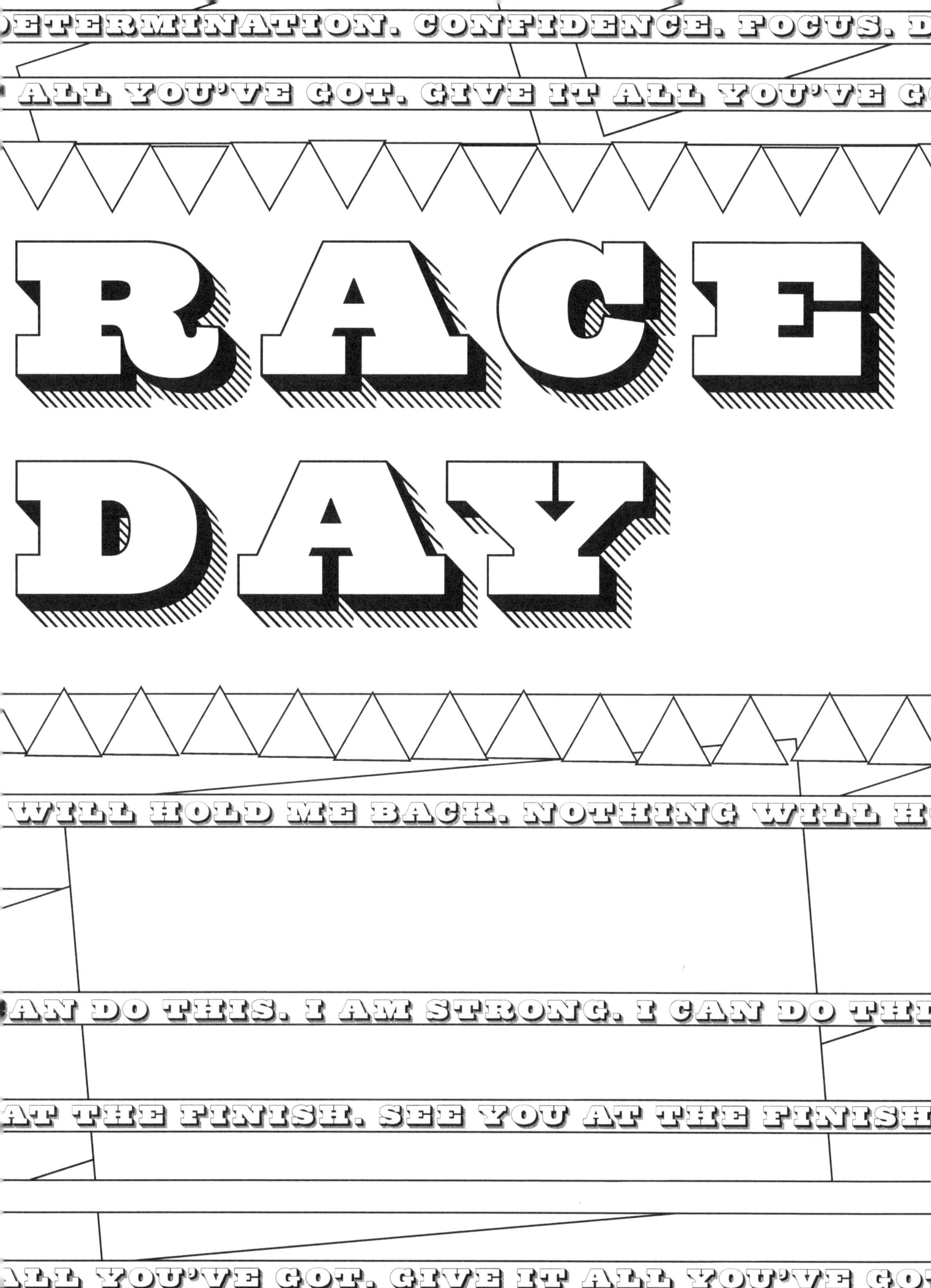

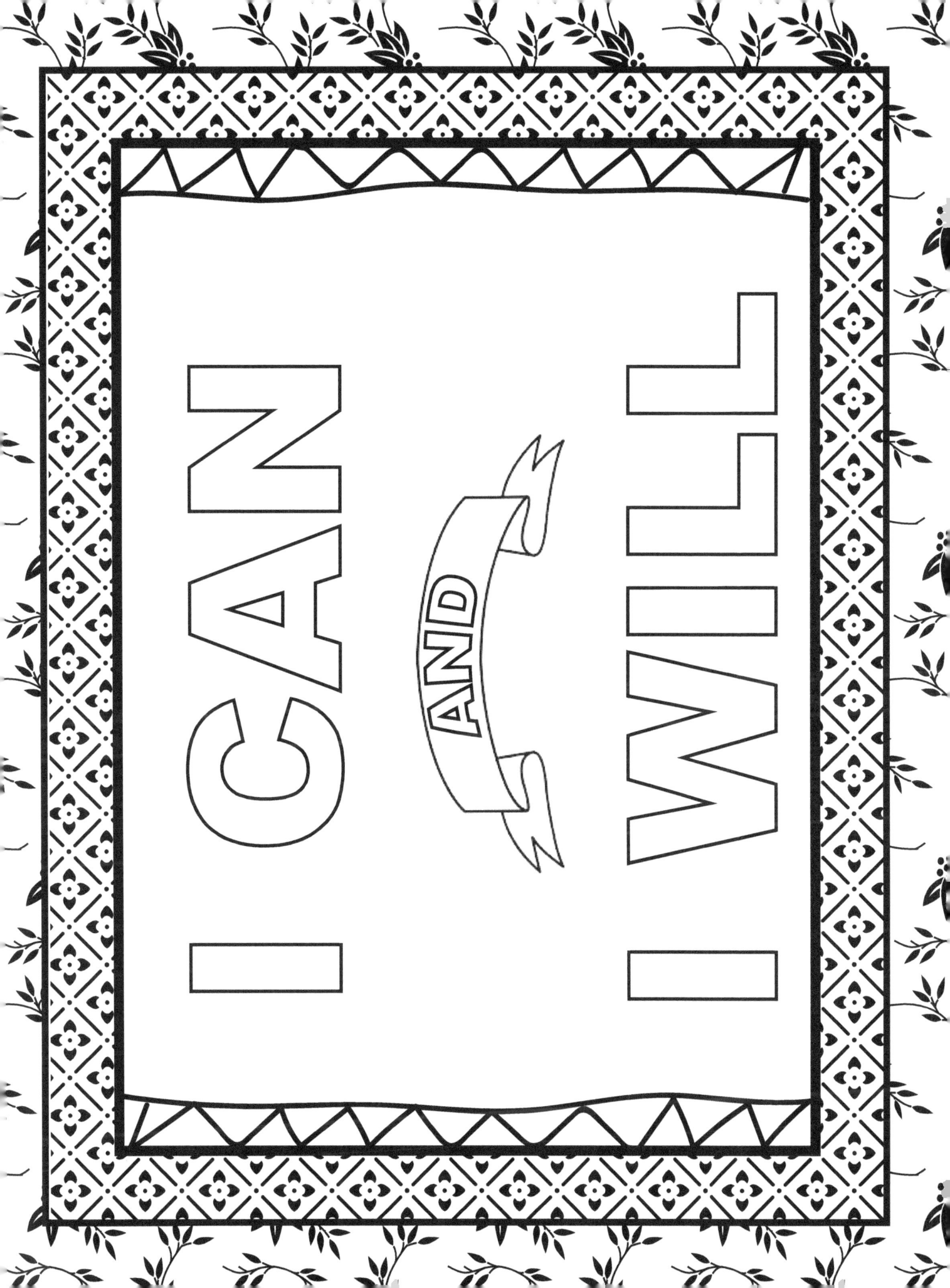

www.ingramcontent.com/pod-product-compliance
Lightning Source LLC
Chambersburg PA
CBHW080607190526
45169CB00007B/2921